On Top of the World

Written by Nicholas Graham

Illustrated by Gabriel Romer

Illustrated by Gabriel Romero | Written by Nicholas Graham

Little Timmy was three years old. The bright-eyed, blonde haired child had a very loving mother. One day, in their spacious living room, Timmy's Mother lifted him high in the sky. It was so high, it scared Timmy and made him cry.

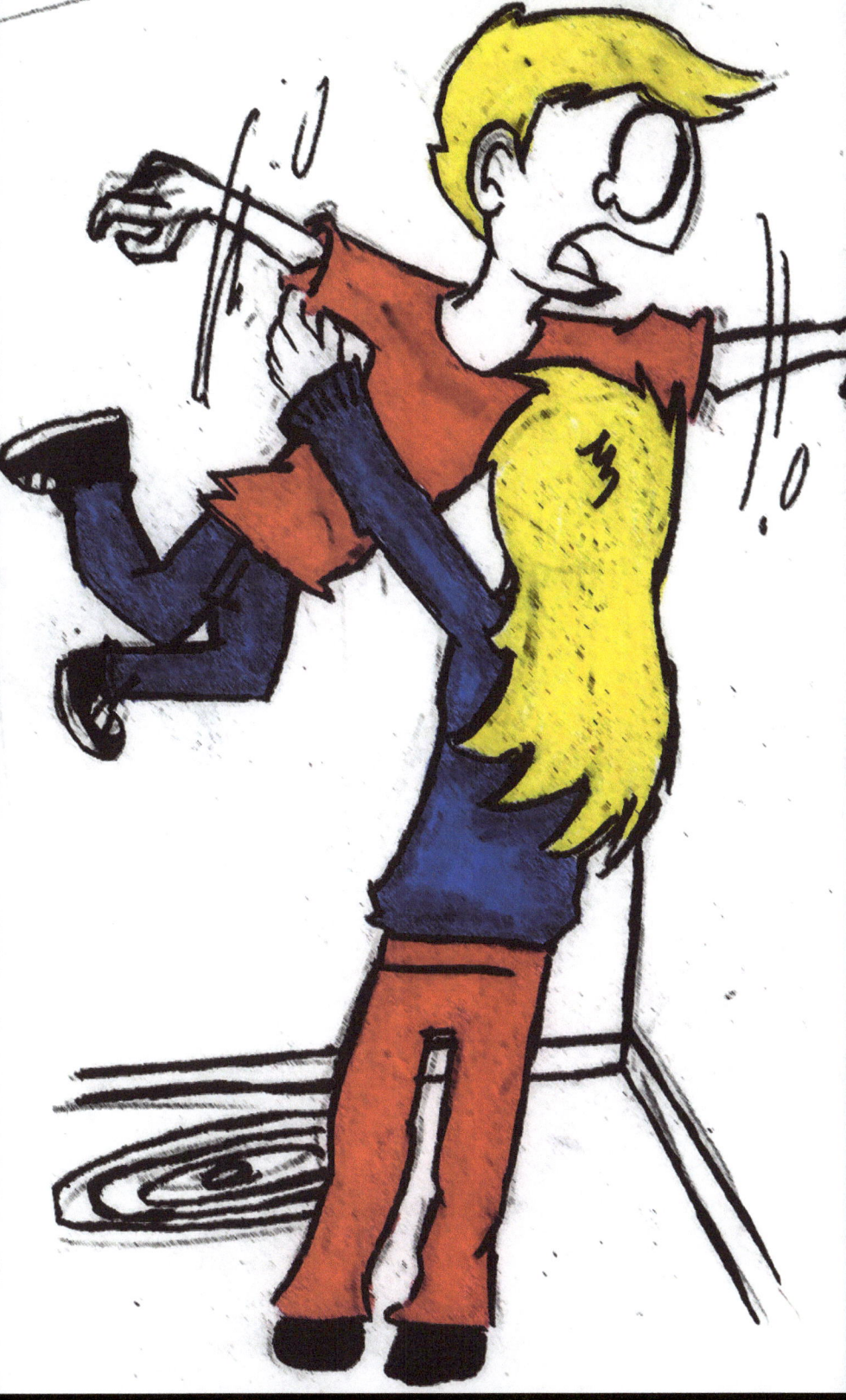

"Its okay honey," Timmy's mom said. "Look, you're on top of the world!" Timmy looked around and saw what his mother was talking about and started grinning from ear to ear as laughter echoed throughout the living room.

Years went by and Timmy was now twelve years old! His loving mother took him to the park down the road from his house. A large park with a playground, swing set, sand box, and a large open field.

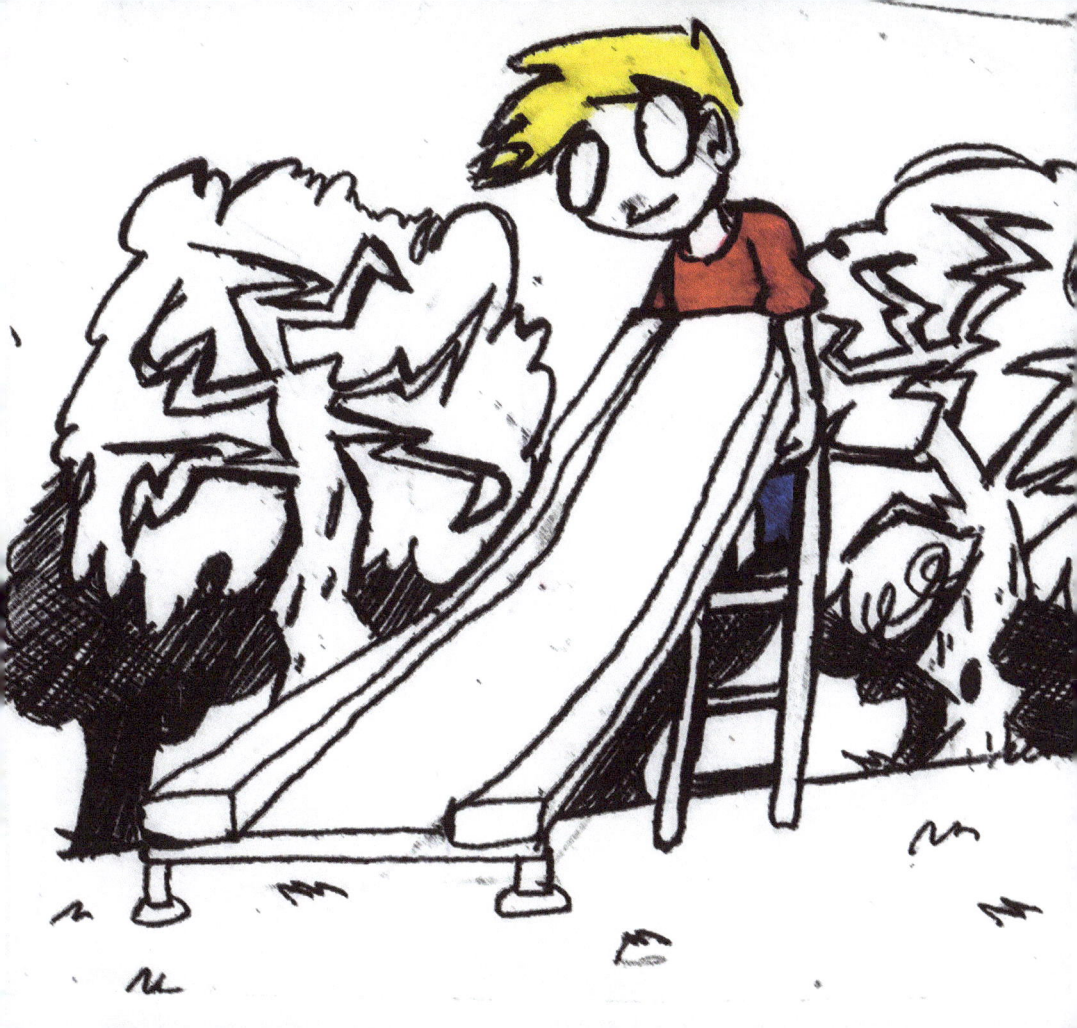

Timmy ran up the slide and got to the very top. He smiled down at his mother, and his mother smiled back.

"Look honey," Timmy's mother said. "You're on top of the world!" Timmy smiled and shouted back at his mother. "I sure am, mom!"

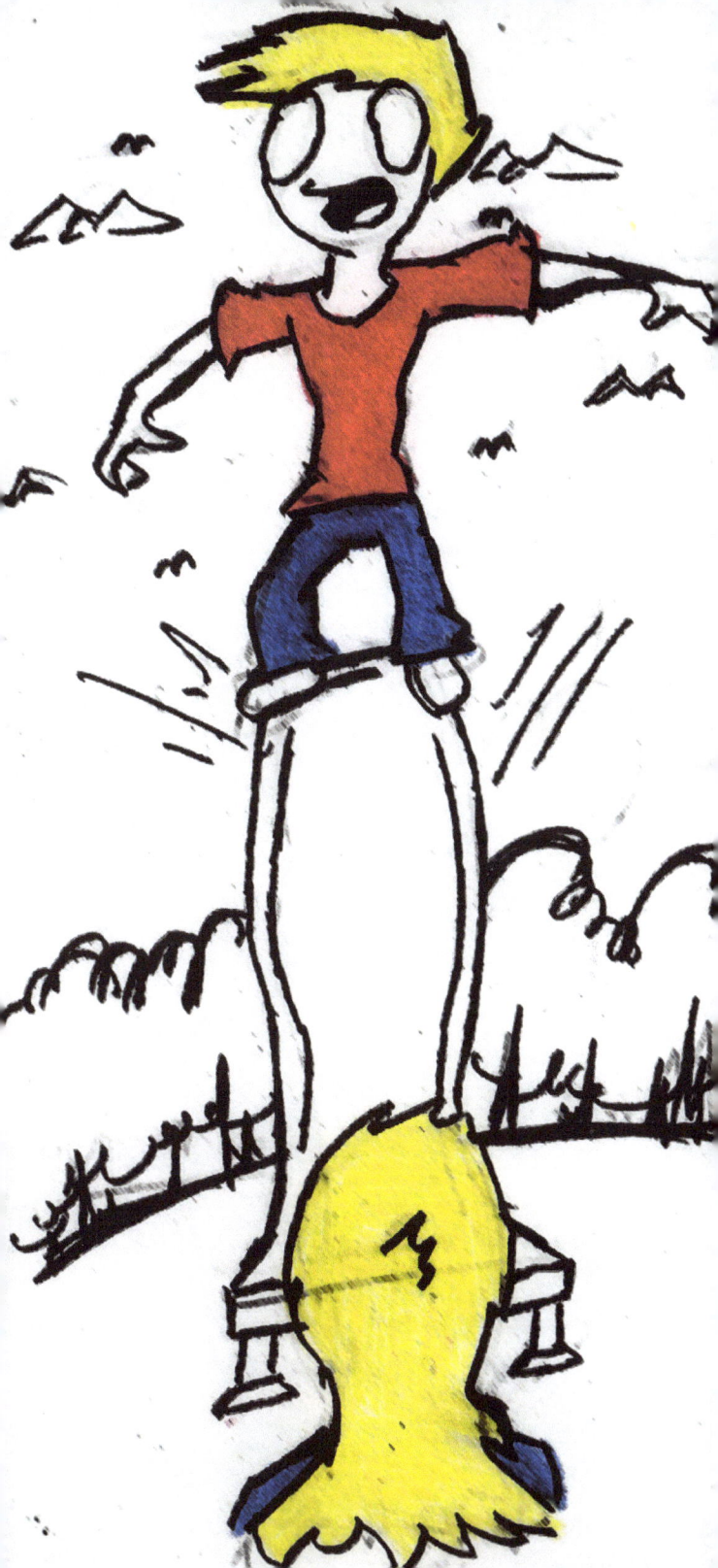

A few more years passed and Timmy was nineteen years old! He packed his things in his mothers house to move out and go to college. His mother drove him to the college three hours away and watched as her son walked away.

Timmy's mother sat in the car and smiled with tears in her eyes and whispered to her self,

"Go get 'em honey, you're on top of the world!"

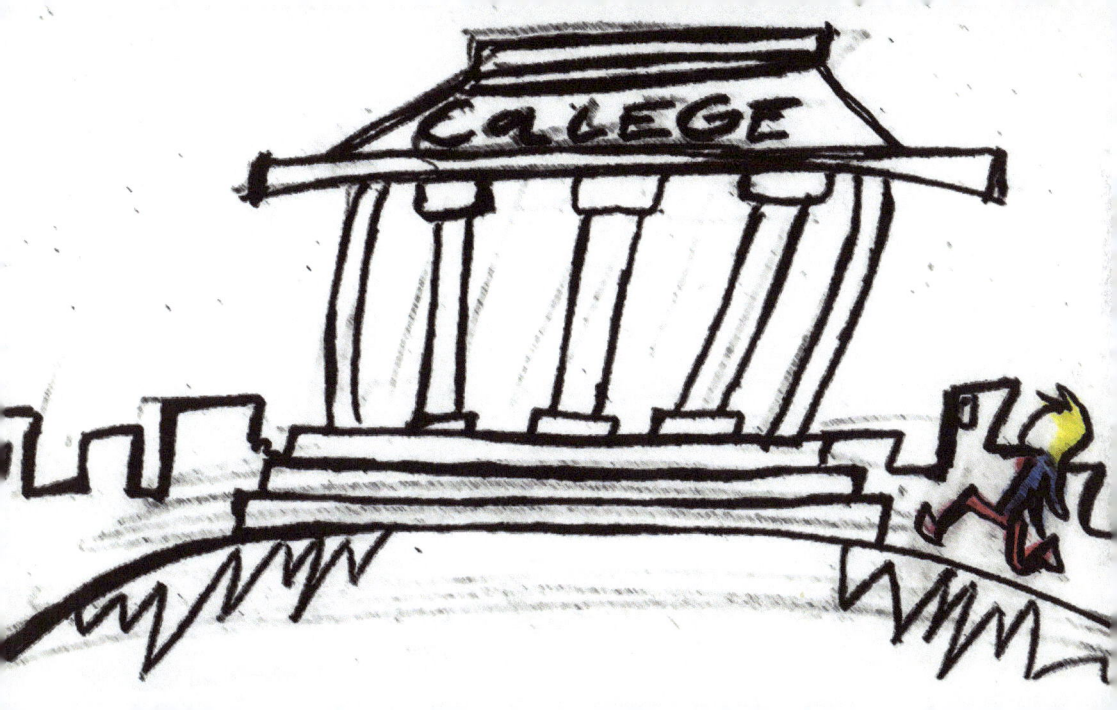

A couple more years passed and Tim was twenty five years old! It was Christmas time and his family always gathered together for a feast. This time, however, the feast was at Tim's nice new big house with Tim's new wife and new baby boy.

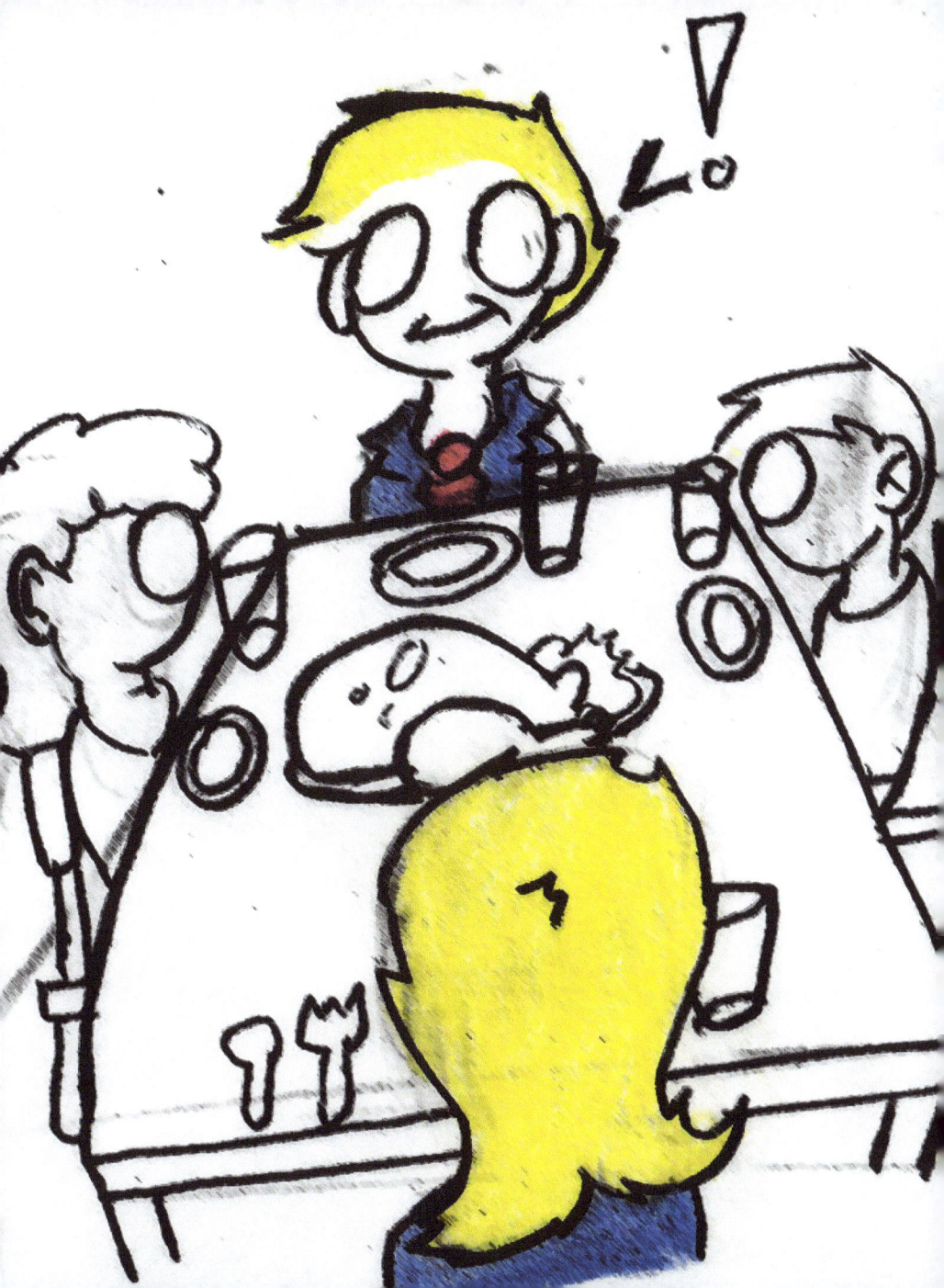

Once dinner was over, and every one left the house, Tim's mother was driving away, then she stopped and pulled over. She looked back at Tim's house and said to her self,
 "I'm so proud of you honey, you're on top of the world!" then continued to drive home.

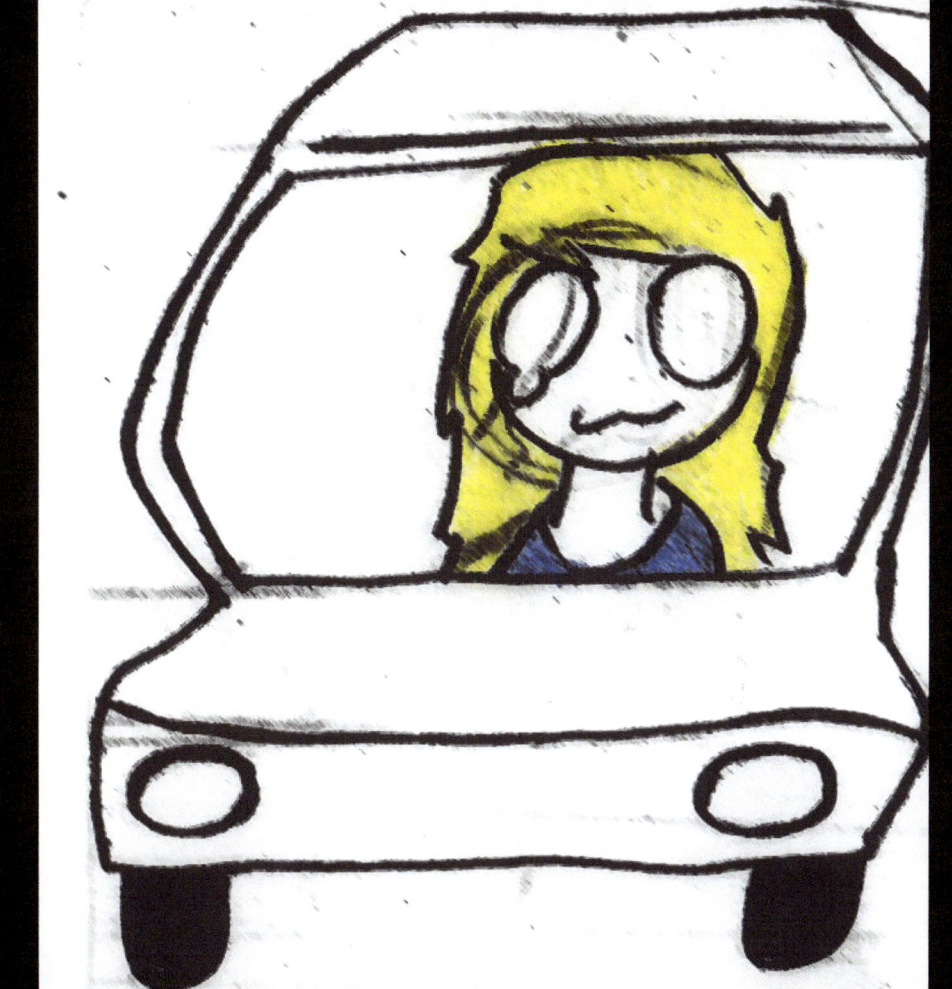

Ten years later, Tim was the manager of a huge business! His office was thirty stories up in a building so high it touched the bright blue sky. Every day his mother, old and fragile, drove past his office on her way to the store.

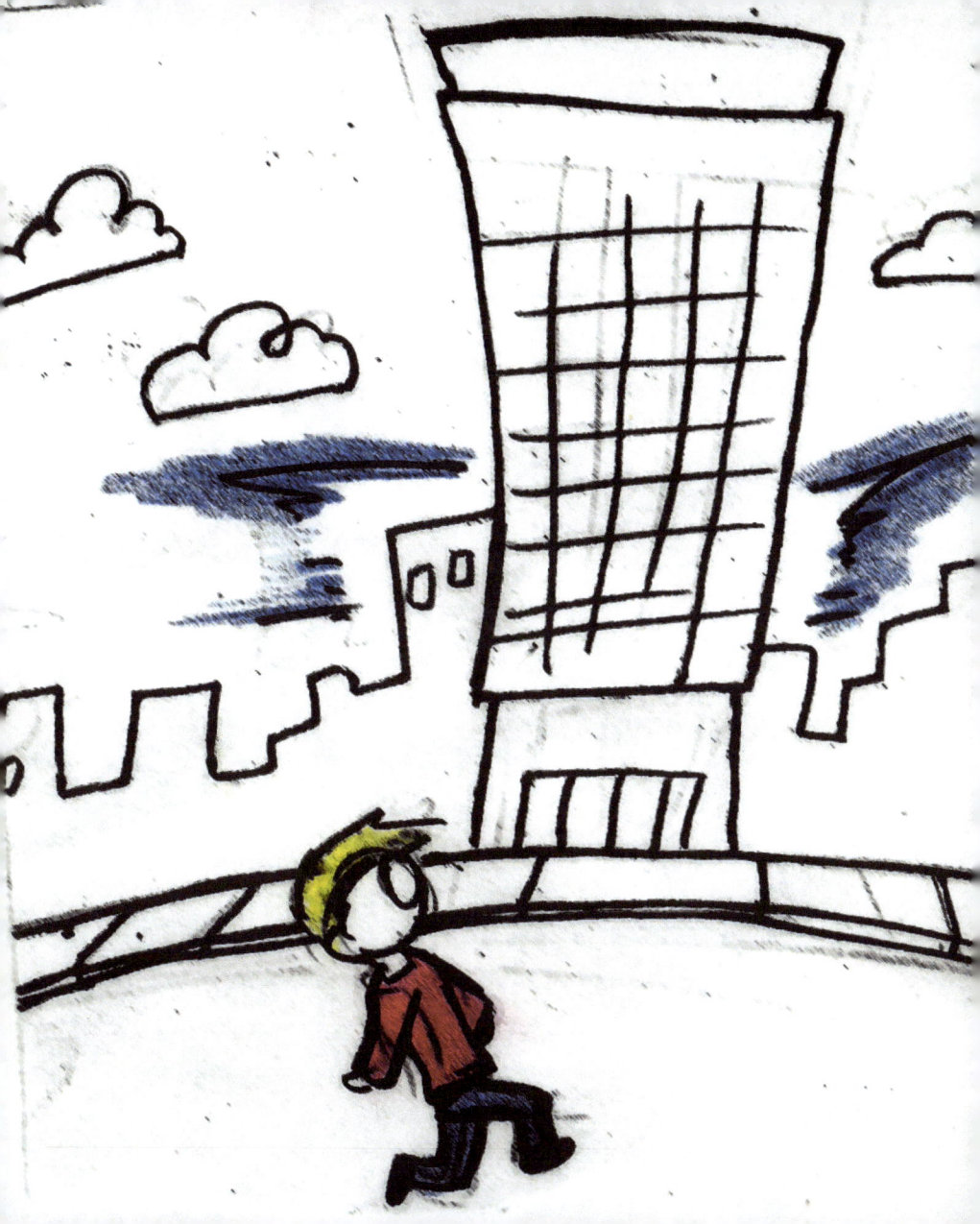

However, one day she parked the car and got out. She looked up as high as she could and smiled. She grabbed the nearest pedestrian and said,

"Look up there sir, about thirty stories up. My son is up there. He is on top of the world!" The pedestrian looked back and smiled.

"He sure is ma'am, he sure is!" then he continued walking.

Ten more years past and Tim's mother became very ill and had to go to the hospital. The doctors said it didn't look good. When Tim arrived the doctors informed him of the condition his mother was in. He walked up to his mother with tears and his eyes, gave her a kiss and said,

"Bye Mother, I really do love you."

Then, his mother turned and smiled back and said,

"I love you too honey, I really do."

Hours passed and Tim's mother past away peacefully.

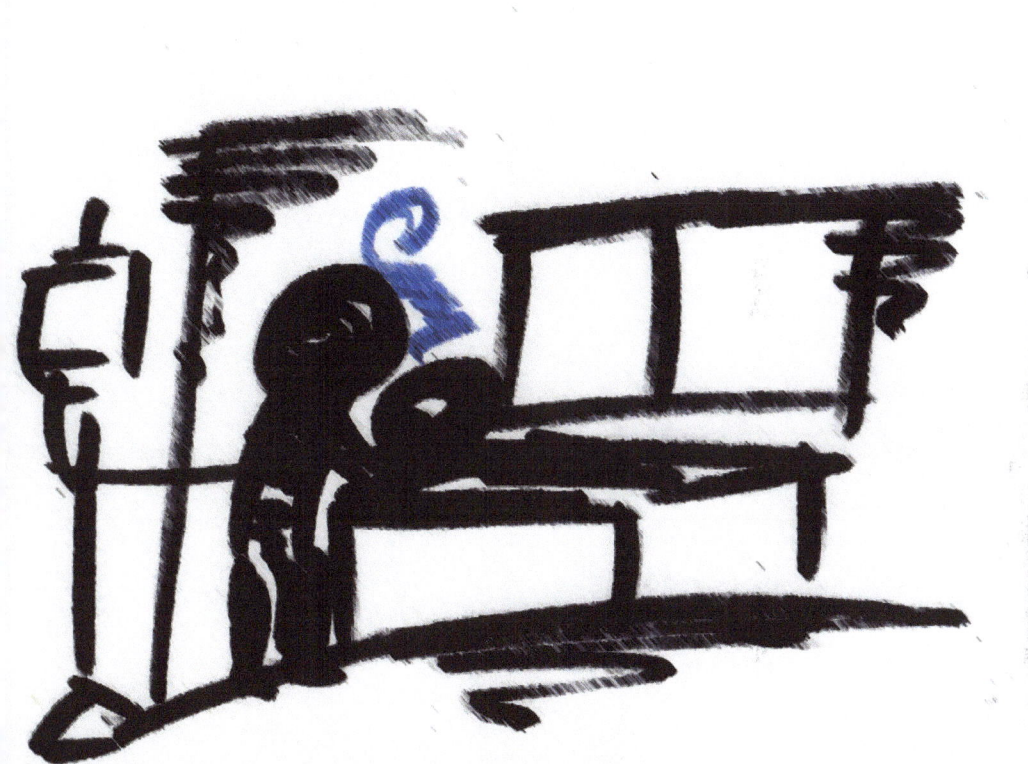

Tim left the hospital with tears in his eyes and he started to drive away. However, he pulled the car over in front of the hospital, got out of the car, looked up at the eloquent sunset and smiled as he said to himself,

"I see you up there mom, you really are on top of the world!"

The end

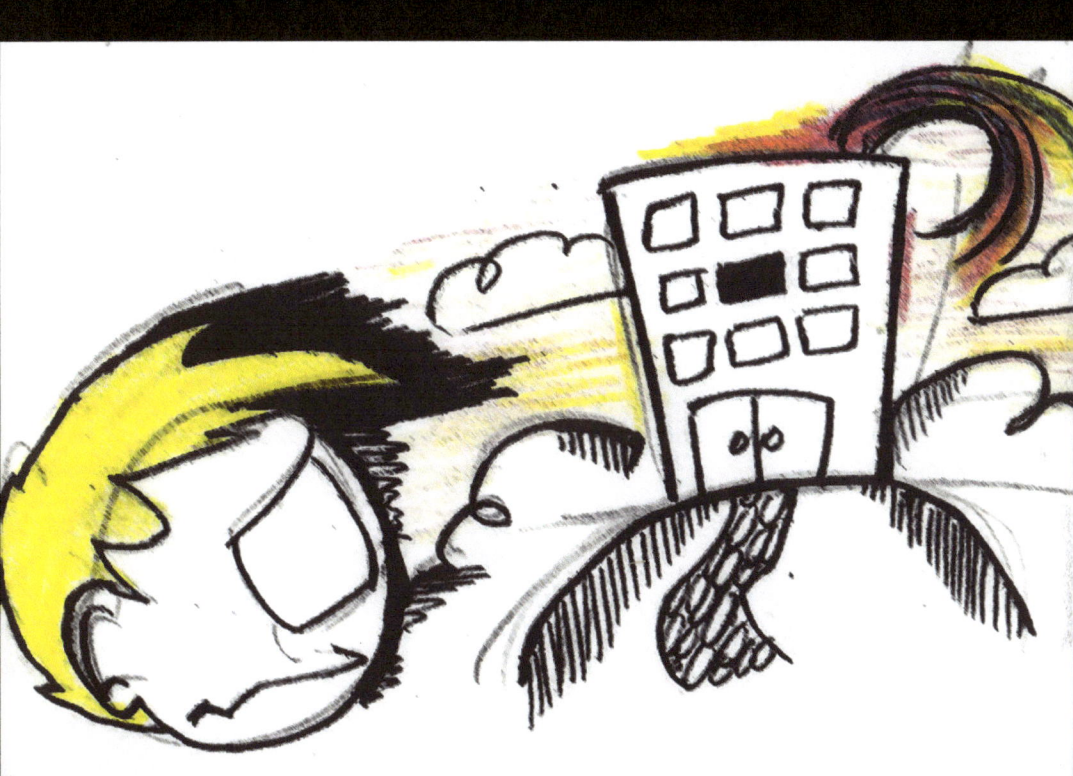